THE
WILDERNESS
COLORS
OF
TAO-CHI

An album of twelve leaves

from the

ARTHUR M. SACKLER

Collection

THE WILDERNESS COLORS OF TAO-CHI

Introduction, commentary, and translations by
MARILYN FU AND WEN FONG

THE METROPOLITAN
MUSEUM OF ART

Distributed by
NEW YORK GRAPHIC SOCIETY
Greenwich, Connecticut

LIBRARY OF CONGRESS CATALOGING IN PUBLICATION DATA

Fu, Marilyn.
 The wilderness colors of Tao-chi.

 Bibliography: p.
 1. Tao-chi, 1630–1707. I. Fong, Wen, joint author. II. Tao-chi, 1630–1707. III. Title.

ND1049.T3F78 759.951 73-9618

ISBN 0-87099-078-0

Mountains and rivers compel me to speak for them:
they are transformed through me and I am
transformed through them. Therefore I design
my paintings according to all the extraordinary peaks
which I have sought out. When the spirit of the
mountains and rivers meets with my spirit,
both their images are transfigured into one,
so that in the end, everything leads back to me.

—TAO-CHI, *Hua-yü-lu*, Chapter 8

INTRODUCTION

TAO-CHI regarded nature as the source of his creativity. Unlike his contemporaries, the orthodox painters of the late seventeenth and early eighteenth century who viewed nature through the styles of earlier Sung and Yüan masters, Tao-chi experienced nature directly and intuitively. Beginning in his youth, he wandered over the peaks of southern China, seeking their inspiration. In maturity, he was able to transmute his visions of nature into works of both monumental and intimate format. In the wilderness, Tao-chi felt his consciousness merging with the mountains and rivers; while painting flowers, he identified himself with their natural purity and symbolic qualities. His feelings for the essential in an object and his ability to capture it spontaneously in the act of painting won the admiration of the critics, and he is today regarded as the leading genius in later Chinese painting.

Born 1641 to a distant branch of the Ming imperial family, Chu Jo-chi (as he was originally named) escaped, when the Ming dynasty fell to the Manchus in 1644, under the protection of a family servant. Having found refuge in a Buddhist temple, he became a monk to avoid further persecution. He adopted the Buddhist names Tao-chi and Yüan-chi, as well as the sobriquets: Shih-t'ao ("Stone Wave"), K'u-kua ho-shang ("Friar Bitter Melon"), Ch'ing-hsiang lao-jen ("The Old Man of Ch'ing-hsiang"), Hsia-tsun-che ("The Blind Abbot"), and in later years, Ta-ti-tzu ("The Purified One").

In the course of his life he resided in a number of great cities. After his early years in Hsüan-ch'eng in Anhwei province (about 1660 onward), he lived in Nanking, Kiangsu (1680–85), Yang-chou, Kiangsu (1685–87), Peking, Hopei (1687–92), and again in Yang-chou from 1692 for the rest of his life. As he achieved fame as a painter, he became reconciled with his Manchu overlords. He was twice received by the K'ang-hsi emperor, once in Nanking and again in Peking. During his Peking years, he enjoyed a wide circle of friends and patrons, among whom was the powerful Manchu clansman Po-erh-tu. He died about 1710.

Tao-chi's art was first molded by the tastes and ideals of his immediate predecessors and contemporaries, Ch'en Hung-shou (1599–1652), Hung-jen (1610–63), Mei Ch'ing (1623–97), K'un-ts'an (about 1612–86), and even Kung Hsien

(about 1620–89). Instead of the more conventional brushwork and colors, these painters exploited a "parched and lean" *(kan-shou)* brush technique on the one hand and a "drenched and saturated" *(lin-li)* ink method on the other. Tao-chi's early works from his Anhwei years display many of these characteristics. His sojourn in Nanking represented a period of maturation: here he developed distinctive pictorial motifs and themes, as well as a wide range of calligraphic styles. His sojourn in Peking showed him further possibilities. His long handscroll *Sketches of Calligraphy and Painting by Ch'ing-hsiang,* dated 1696 and now in Peking, sums up his achievements to this date and shows the directions of his later developments.

His greatness, however, lies not only in his painting but in his painting theory. His treatise, *Hua-yü-lu (Notes on Painting),*[1] presents his views on the art of painting, the cultivation of self, and the relationships existing among painting, the painter, and the cosmos. Although the *Hua-yü-lu* stresses equally the spiritual and technical aspects of art, Tao-chi was not primarily a philosopher. He was a painter, and we can only guess at the depth of his religious and philosophical thoughts through their implicit influence on his art. His affiliations with Ch'an (Japanese, Zen) and his later interest in Taoism (the name of his studio in Yang-chou, "Ta-ti-t'ang," or "Hall of Great Purity," alludes to a Taoist site, Mount Ta-ti in Hang-chou) were acted out through his paintings. He seems not to have pretended to the practice of Ch'an, and in fact he wrote: "I don't know how to explain Ch'an, and I don't expect alms. I merely sell landscapes done in my leisure hours!"[2]

The unifying principle Tao-chi advanced for the understanding of painting as well as cosmic creation was called *i-hua,* which means both "the single stroke" and "the painting of oneness." *I-hua* was at once the symbol and realization of primordial growth—the processes of nature in both the general and specific senses. *I-hua* also constituted the very practical operating procedure in painting: the completed design depended on the direction and configuration of the first single stroke from which everything else grew. The accidental effects that Tao-chi sought in his work were directly related to this concept of "single stroke" painting, or painting of "myriad strokes that are ultimately reunited in oneness." The creative processes of growth and renewal were embodied in the very act of transmitting the artist's energies through the brush and ink. The spontaneous control of brushstrokes, ink suffusion, and blotting made of painting a physical exercise and through this a form of self-realization for the artist.

A central theme in Tao-chi's art theory is the relationship between painting and calligraphy. It is the Chinese writing brush, with its sensitive tip, that permits the fundamental unity of pictorial and calligraphic expression. Tao-chi spoke of this unity in a time-honored fashion:

The ancients combined the Eight Principles of calligraphy with the Six Principles of painting to form the method of painting. Therefore my brushstrokes sometimes resemble the "running" script, sometimes the "regular" or "seal" scripts, or even the "grass," "clerical," or other methods.[3]

Tao-chi consciously employed a great variety of styles in both his painting and calligraphy. Yet by always maintaining a strong personal identity in whatever style he employed, he was able to achieve "oneness" through diversity, while at the same time creating infinite change with his "single stroke." This brings us to his attitude toward techniques and methods, which he often treated in the paradoxical language of the Ch'an master. "The perfect man," he wrote, "has no method. But it is not that he does not have method; he has the perfect method that is no method."[4] The secret of creation, for Tao-chi, was *pien* or transformation. Since transformation implied transcendence, it depended on the firm identity of one's own style. Tao-chi admired the achievements of the ancient masters no less than his contemporaries the orthodox painters did. But for him the question was not whether ancient masters should be studied or not, but rather that in imitating an ancient style one must inevitably alter and transform it into one's own style. In this connection, he summed up his individualist credo:

I am what I am because I have an existence of my own. The beards and eyebrows of the ancients cannot grow on my face, nor can their lungs and bowels be placed in my belly. I shall vent my own lungs and bowels, and display my own beard and eyebrows. Though on occasion my paintings happen to resemble someone else's, it is he who comes near to me, and not I who deliberately imitate his style. This must be naturally so. When indeed have I ever studied ancient masters without transforming them?[5]

Painting, according to Tao-chi, "is an expression of the *hsin*"[6]—a word meaning both "mind" and "heart," intellect as well as feelings. For Tao-chi, the affective aspect of his art was especially important. "Employing brush and ink to write out the myriad things of heaven and earth makes my heart feel joyous," he wrote.[7] It is this feeling of joyousness that enables Tao-chi's art to appeal directly today to a Western audience.

The present album of twelve leaves, which is in the Arthur M. Sackler Collection in The Metropolitan Museum of Art, was painted between 1697 and 1700. The signature on the last leaf mentions his studio Ta-ti-t'ang in Yang-chou, which was probably built early in 1697.[8] Four of Tao-chi's seals in the album help us to date the work in the late 1690s: Ch'ien-yu Lung-mien, Chi (leaves 3 and 7), Ch'ing-hsiang lao-jen (5, 6, 9), and Yüeh-shan (10), and Tsan-chih shih-shih-sun, A-ch'ang (8, 12). The first three usually appear on works dated between 1693 and 1703, the fourth on works after 1701.[9]

Tao-chi's seals, in both relief and intaglio designs, are all found, in this album, close to his writings. The seals are carefully chosen with regard to sizes and designs. Those following his signatures show several of his sobriquets. One on leaf 2, appearing in the upper right corner of his inscription, reads *yu-hsi,* "a recreation"; this is known as a *hsien-chang* or "idle seal," which records the artist's comment rather than his name. The seals found in the corners of the leaves are those of collectors who once owned the album. Leaves 7 and 9 bear the seals of Ching Ch'i-chün (about 1852).[10] The rest of the seals are those of Chang Dai-chien (also spelled Chang Ta-ch'ien), a well-known painter and collector of today. The photograph of leaf 2 that appears in *Shih-t'ao hua-chi* (*Collection of Shih-t'ao's Paintings*), published in Peking, 1960, shows the leaf before Chang Dai-chien's seal was added.

The painting and calligraphic styles found in the album closely resemble those in Tao-chi's handscroll, already mentioned, *Sketches of Calligraphy and Painting by Ch'ing-hsiang.* The wide range of calligraphic styles in the album is by itself a certain indication of a date in the late 1690s, which saw Tao-chi at the height of his creative power; the sensitively controlled "regular" script found on leaf 12, for instance, is no longer seen in his work after 1700.[11]

The writings, as comments, were always done after the paintings. Since no preliminary drawing was used in any of these paintings, the design of the calligraphy, like that of the painting, involved spontaneous decisions and an improvisational approach. The type of script, the shape of the writing columns, the size of the individual characters and of the individual strokes, as well as any rhythmic emphasis or flourishes—each and all of these bear on the final success of the finished leaf. The fact that each leaf, once complete, can be neither altered nor added to in any of its component parts proves the essential creative unity of Tao-chi's "single stroke" painting. Although the finished composition, especially its more salient formal idiosyncrasies, can be copied and imitated, the creative tension and unity among the parts—the kinesthetic sense of flow that reveals something of the creative process—is in each case unique, original, and inimitable.

The significance of the calligraphy on these leaves is more than visual and pictorial. As captions, the texts provide important clues to the painter's thoughts. Tao-chi selects lines from two great T'ang dynasty poets, Li Po (701–762) and Tu Fu (717–770). The poems from which the lines come are not available in English but may be found in Chinese publications of the poets' collected works. The quintessential Chinese romantic poet and a noted lover of wine, Li Po was the virtuoso stylist. The lines of Li Po that Tao-chi quotes on two of the leaves (1 and 3) are rich in visual imagery. In Tu Fu's lines Tao-chi found the emotional intensity he wished to express in his paintings. As one of China's great humanist poets, Tu

Fu had chronicled the sufferings of his time in language that was at once simple and vivid. He had known war and exile, and he spoke for the common man and yearned for the ordinary things in life. In his capacity for compassion and in his ability to smile at himself in adversity, Tao-chi obviously found a kindred spirit in the poet. Thus, on leaf 9 a seemingly ordinary autumnal scene suddenly takes on a dark, emotional tone with a couplet from Tu Fu, and leaf 5 shows Tao-chi building a sequence of image and thought on some lines by Tu Fu. On some of the leaves Tao-chi inscribes his own poems and comments. Leaves 4 and 6 demonstrate his approach as a painter. Leaves 2 and 8, in portraying two common vegetables and speaking about ways of eating them raw, reveal his robust and humorous personality. Leaf 2 documents Tao-chi's friendship with Wang Kai (active 1677–1705), the illustrator of the *Mustard-Seed-Garden Painting Manual* (*Chieh-tzu-yüan hua-chuan*), which is a relationship unknown to us except for this evidence.

The remarks about eating raw vegetables in this album have an aesthetic significance. In China, during the early eighteenth century, one of the liveliest critical discussions centered upon the question of "rawness" (*sheng*) and "ripeness" (*shou*) as indications of different degrees of personal cultivation in painting. The leading orthodox master Wang Hui (1632–1717), for instance, was criticized for being "too ripe" on account of his superb technique, while Cha Shih-piao (1616–98) was thought to be "too raw."[12] While for some, mastery of technique resulted in "overripeness," and for others, technical coarseness caused "rawness," the ability to transcend the limitation of an acquired technique led to another kind of rawness, which can best be described as a state of enlightened innocence. By repeatedly speaking of eating his favorite vegetables raw, Tao-chi clearly indicates his desire to free his art from all artifice, thereby returning to his raw or true self. He proudly informs us that the painting on leaf 10 is "raw." This quality is evident throughout the album.

We here express our indebtedness to Professor L. S. Yang of Harvard University for his help in interpreting the meanings of leaves 8 and 12.

<div align="right">

MF
WF

</div>

LIST OF PLATES

I. MOONLIT GEESE

A slope of land, a tile-roofed building with crenelated outlook, some trees, and the masts of skiffs tied along the shore fill the left corner of the page. In the upper half, thick groves lie straight across the horizon. The lines above are from Li Po's "Climbing Yüeh-yang-lou with Mr. Hsia":

> *Wild geese lead away a mournful heart,*
> *But mountains bring back a full moon in their teeth.*

Yüeh-yang-lou was a storied building overlooking Lake Tung-t'ing, a famous scenic spot in Hunan province much frequented by poets and painters. The structure was erected in the eighth century A.D., and, long before Tao-chi's day, it had acquired a wealth of associations that later poets drew upon and further expanded by their eulogies. The mere mention of Yüeh-yang-lou could trigger a complex net of remembrances acquired through one's personal experience and literary culture.

Pictorially, a pavilion separated by water from moonlit mountains could function in a similar way. Here, Tao-chi has employed a classic "one-corner" composition, originally made popular by the Southern Sung masters of the twelfth and thirteenth centuries, recasting it in highly kinesthetic ink strokes and color patterns. As we focus on the deftly drawn details of masts, geese, moon, and moon-gazing human visitors, we can feel the tension of being drawn away by the geese and pulled back by the moon, as the poem suggests.

In contrast to the simple drawing, Tao-chi has written the text in a monumental "clerical" script *(li-shu),* characterized by broad configurations, with short verticals and long, flaring horizontals and diagonals. Tao-chi treated *li-shu* as his favorite decorative script. It evolved during the Han period (206 B.C.–A.D. 219) and was the first script to make full use of the expressive potential of the brush. Its fundamental ornateness is enhanced here by Tao-chi's choice of paper, a highly absorbent variety that lets the ink bleed at the edges of the strokes.

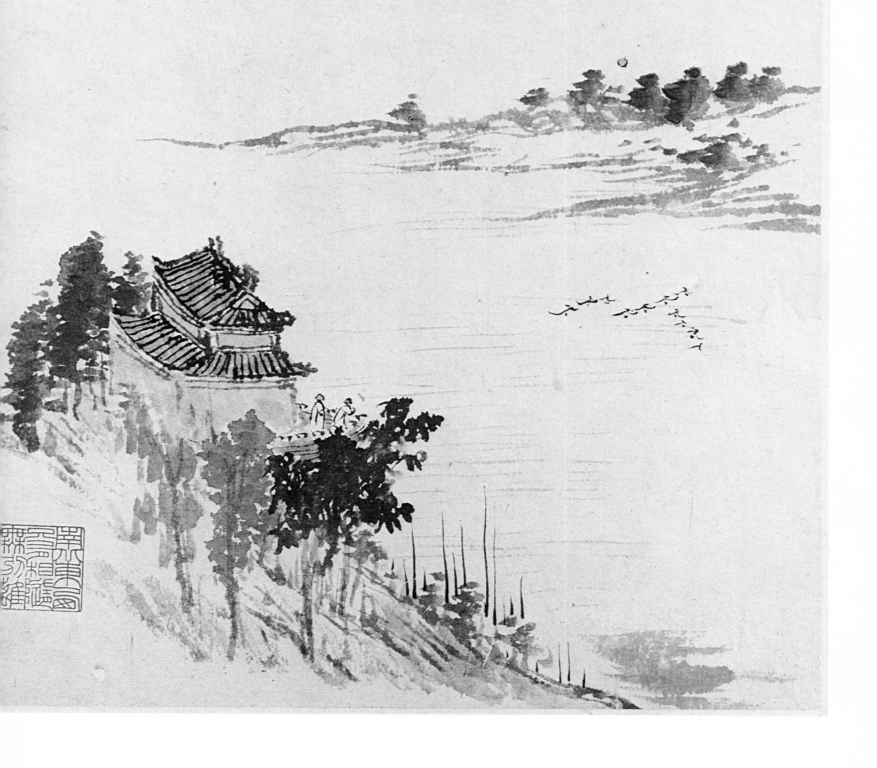

雁引愁心去山街好月來李白與夏十二登岳陽樓句道以偶寫之

2. TARO-ROOT

Taro is even today a staple of the Buddhist monk's vegetarian diet. It has a bland, rustic flavor and a starchy texture. The root's robust shape and coarse skin with root-hairs make it an interesting pictorial subject. Tao-chi was one of the first to portray the taro, and in doing so he extended the still-life repertory of scholar and monk painters. His inscription reads:

> Once Wang An-chieh presented me with a poem, saying: "Get some spring water in your copper bowl, and roast some taro in the earthen stove." He truly understood me. But what a laughable, uncouth person I am! This year I greedily obtained some huge taro-roots. They were too large to be roasted in a short time, so I ate them all partly raw. Can you guess what the temperature is inside my stomach?

The last line is a double entendre: the temperature (huo-hou) refers not only to cooking in the literal sense, but also to one's inner character and resilience in dealing with adversities in life.

Having first mapped out his design with pale wash, Tao-chi used a partially inked brush to create the curved surfaces of the root. The white paper showing between the dry brushstrokes effectively creates texture and volume; the technique is called "flying white" (fei-pai). The arrangement of the roots and the leaves seems natural and uncalculated. Graded ink and color washes play an important role: the darkest ink is reserved for the largest root, its drier textures standing out against the background of paler, wetter, cheerfully colored shapes.

The calligraphy, a combination of the "clerical" and the "regular" (k'ai-shu) scripts, recalls the style of the Yüan painter Ni Tsan (1301–1374). The wiry strokes amusingly echo the taro's root-hairs. Tao-chi emphasizes the natural rhythm of the writing by permitting the characters to grow thinner as the brush dries and large again when the brush is reinked.

Wang An-chieh was the style name of Wang Kai (active about 1677–1705), the compiler and illustrator of the famous *Mustard-Seed-Garden Painting Manual,* published between 1679 and 1701.

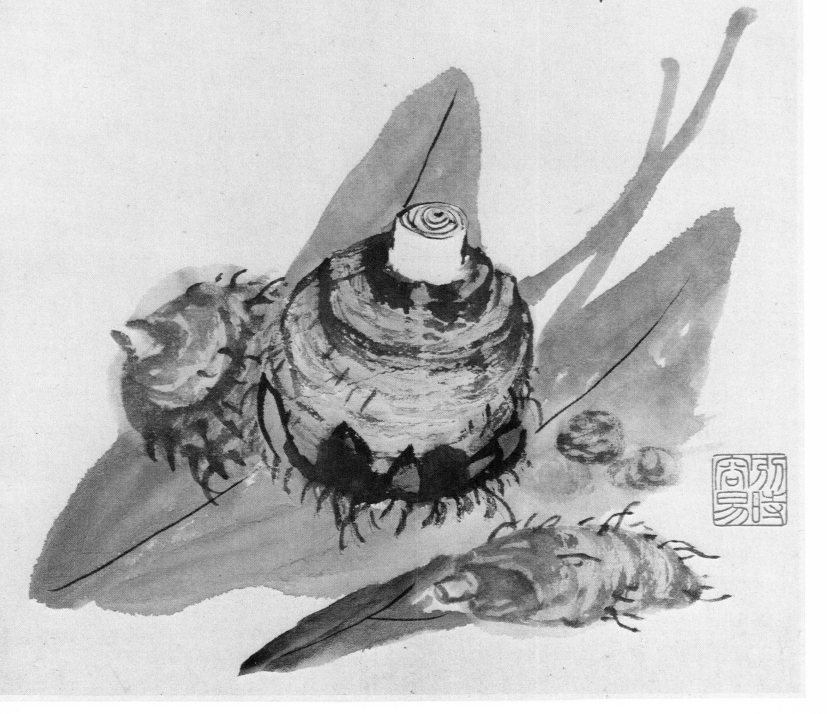

苕王安節贈予
有詞云銅缽分泉
土爐煨芋信知予
者也郤可笑野人
今季饞幾箇大芋
子一時煨不熟都
帶生吃君試道腹
中火候存幾分
清湘石道者濟

3. RIVERBANK OF PEACH BLOSSOMS

The lines are from Li Po's "Parrot Island":

> *The mist parts, and the fragrant breeze from*
> *the orchid leaves is warm;*
> *The riverbanks are lined with peach blossoms,*
> *rising like a brocaded wave.*

Although Parrot Island, an actual locale in Hupei Province, had long and complex historical associations, Tao-chi here concentrates on Li Po's imagery. Laying down shimmering tones of scarlet, blue, and yellow, one over another in a quick succession of dabs and smudges, he conveys both the brilliance and the softness of flower petals on a misty sunlit day.

Painting in color without ink boundary lines is known as the "boneless" method *(mo-ku-fa)*. Used primarily with flowers, the method is said to date back to the T'ang dynasty. Tao-chi, a master of colors, employed *mo-ku-fa* for landscapes and extended its expressive possibilities by piling up moist gradations of contrasting hues to give depth and substance to his forms.

The free and ethereal quality of the present landscape is set off by the elegance of the highly controlled writing, a version of the "regular" script modeled after the style of the Wei dynasty calligrapher Chung Yu (151–230). The squat shapes, thin horizontals, broad verticals, and the slow, even-paced execution are all typical. Tao-chi's personal interpretation can be recognized in the precisely articulated brushwork and the exaggerated spacing between the strokes.

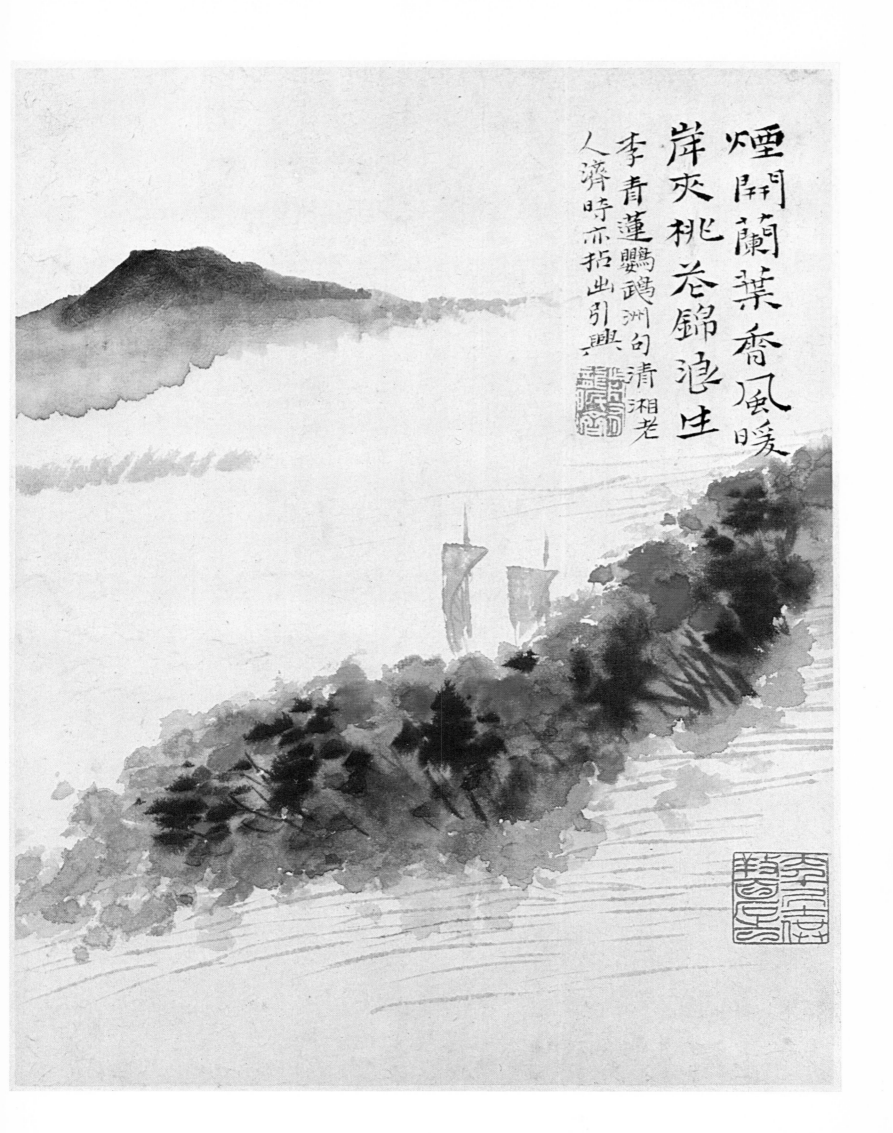

煙開蘭葉香風暖
岸夾桃花錦浪生
李青蓮鸚鵡洲句清湘老
人濟時亦拈出引興

4. ON PAINTING BAMBOO

Sprightly bamboo and free, running calligraphy share the picture space, achieving a dramatic union of visual and verbal expression. Tao-chi has not painted his bamboo as a static still-life subject; instead, he has made a statement about bamboo painting as a way of understanding and communicating with nature. He says:

> *Ruined leaves and sparse branches are best*
> > *painted from life.*
> *Draw some high, some low, here and there,*
> > *as if they had feelings.*
> *One need only face the bamboo alone, and drink*
> > *away for ten years,*
> *Then when the brush turns out the bamboo roots,*
> > *you hear the swishing sounds.*

The goal in bamboo painting is natural vitality; the artist's psychic energies are transmitted into the brushlines through the physical momentum of the brushstrokes. Paler ink has been used in the branches; these are drawn with staccato accents of straight, blunt strokes, softened by the vines winding around them. The confident, ductile brushstrokes and the rhythm of the trailing tips are repeated in the "grass" writing *(ts'ao-shu)*. The drawing moves from left to right, from the bottom of the branch to the final spray of leaves, and as the drawing turns into calligraphy, the hand moves down from the upper right corner of the inscription, rapidly proceeding, line after line, toward the left, finishing with a last great flourish just above the line of signature.

敗葉離披紛盡寫
生平高亢不求媚
情此須眉薄
十年頗頗賴筆
倒根豈敢自
瞻蘆書寄石濤

5. BIRD WATCHING

Tao-chi often portrays himself in his paintings—searching for plum blossoms, sitting or standing on a mountaintop, or sailing through a gorge. Here we see him standing in a grove on a marshy bank, watching a flock of birds perched on the uppermost branches. The inscription gives us two lines from Tu Fu and a comment by the painter:

> *Glancing up, I linger on the birds,*
> *Turning around, I answer the wrong person.*
>
> I have often followed the old gentleman,
> but have I also managed to "skip over the difficult word"?

Tu Fu's lines, which describe the carefree scholar entranced by spring scenery, were followed by: "In reading books, I skip over the difficult word." Having shown us the birds, Tao-chi allows his mind to dwell on the line he does not reproduce. His comment might be taken to mean: "Have I survived the difficult in life?"

In the late 1690s, with the political situation in southern China being stabilized under the Manchu rule, refugee artists, Tao-chi among them, began to lead a more assured life. Tao-chi had, in fact, by this time "survived the difficult in life." The drawing here is sketchlike and bold: the ink is allowed to run together with the color washes, and the dots suffuse and blot over the scholar's robe. The painter clearly revels in the accidental effects of the brush and ink and is able to exploit them spontaneously as they grow on the paper.

The writing, less spirited than that of the preceding leaf, is in the freehand "running" style *(hsing-shu)*. It is as free and effortless as the drawing.

6. PEACH BLOSSOMS AT MY WINDOW

A spray of blossoms is accompanied by lines of calligraphy flowing in a parallel rhythm. The poem is by Tao-chi:

> Spring breeze and gentle rain come to the window
> of my mountain lodge;
> Even now I paint peach blossoms in their colorful attire.
> I laugh at myself that in spite of old age I have not
> learned to live with leisure,
> And must still play with my brush to pass the time.

Next to the plum, the peach blossom was Tao-chi's favorite flower. The ink strokes here are rich, the use of color is bold, and the writing is free and natural. The petals are drawn in single strokes of graded scarlet, and each blossom appears to catch the light at a different angle—in profile, full-face, or three-quarter view.

The painting seems bright and cheerful, but the poem conveys a different sentiment. The aging Tao-chi feels it necessary to apologize for painting the flower in glorious bloom. Perhaps the act of painting blossoms aroused a feeling of rejuvenation in him.

The twisting of the brush in the petals and leaves is carried into the calligraphy. The freehand script, already seen on leaves 4 and 5, is here more sinuous and sensuous, befitting the nature of the flower represented.

春風細雨到山膝
郤宜桃花似胭脂
花自笑開不待時
西源北尋
夢蕉

過時光

7. WILDERNESS COTTAGE

A couplet from Tu Fu inspires this serenely monumental scene:

> *The luster of bamboo encloses the wilderness colors,*
> *The reflection of a house ripples in the flowing river.*

The man reading in the house may represent Tao-chi himself. Better than the others in the album, this leaf demonstrates Tao-chi's basic method of landscape painting. The composition is of the simplest kind: a massive triangular "host" mountain supported at waist level by rows of distant "guest" peaks. Instead of designing through the balance and harmony of the parts, however, Tao-chi in typical seventeenth-century fashion created compositional movements with kinetic brushstrokes. Individual brushstrokes, foliage patterns, texture strokes, dots, ink and color washes crisscross each other, growing and expanding until the whole turns into a great flowing pattern of undulating forces and counterforces.

For Tao-chi, the individual brushstroke, or "single stroke" *(i-hua),* was "the basis of all things and the root of ten-thousand phenomena, the beginning and the end of myriad strokes of brush and ink." Complementing the unitary principle of "single stroke" was the dual *yin-yang* relationship of the brush and the ink; layers of strokes, some allowed to fuse when moist and some to dry, create a variegated tapestry of textures: substances, things, and life. In the *Hua-yü-lu,* chapter 7, Tao-chi puts it this way:

> When the brush is united with the ink, *yin-yün* (cosmic atmosphere) is created. When *yin-yün* is undivided, it is like chaos. In order to open up chaos, what else should I use except the "single stroke"? Even if my brush is unlike the usual brush, my ink unlike the usual ink, and my painting unlike the usual painting, there is always my own identity in it. It is I who use the ink, the ink does not use me; I who wield the brush, the brush does not wield me; I who grow out of the womb, the womb does not discard me. From one, ten thousand things come, yet from ten thousand things I must come back to one. By transforming the "single stroke" into *yin-yün,* all things under heaven may be accomplished.

In contrast to the monumental landscape, the inscription is relatively small, executed in a neat "regular" script in the style of Chung Yu.

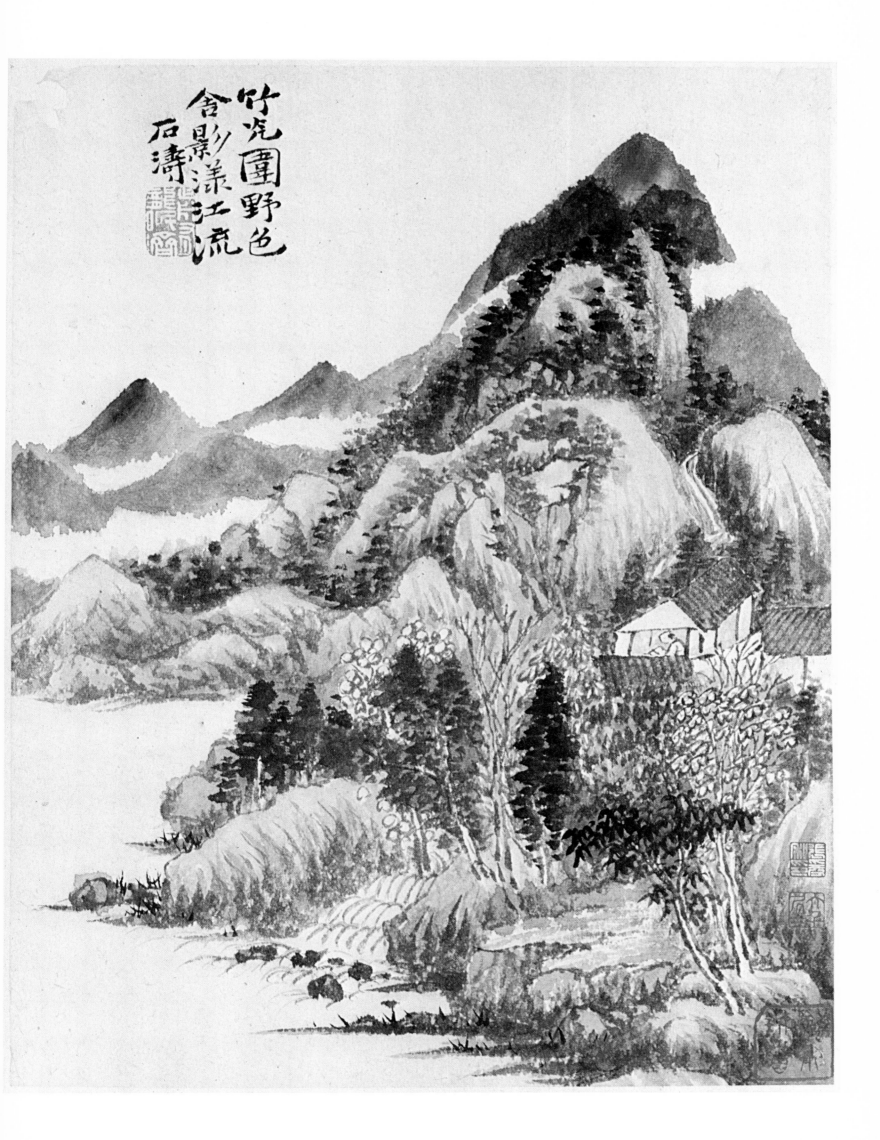

竹光圍野色
舍影漾江流
石濤

8. EGGPLANTS

This apparently innocent still life conceals a strong political sentiment. The clue seems to be a saying by Confucius: "I hate the purple for taking the place of vermilion." Vermilion (*Chu*) was the surname of the Ming royal house. Tao-chi's inscription reads:

> Purple melon, purple melon—they have an exceptionally fine flavor. You tell me how much salt and pickle sauce they need. But I made a mistake. I picked them up and swallowed them raw as if they were wild plants. I hope they will not sprout and take root inside me!

The brushwork that represents the plump vegetables and the reed that ties them together is so swift and clean that the whole bundle looks freshly brought back from the market. Like the picture of the taro, this painting shows Tao-chi's pleasure in common items of food and his ability to elevate them to a high level of aesthetic interest.

The broader meaning of enjoying fresh, raw vegetables is mentioned in the Introduction. Deriving as they do from Tao-chi's personality, the drawing, the calligraphy, and the comments are as vibrantly "raw" as the vegetables themselves. The calligraphy, in the "running" script, following the smooth, ovoid forms, is appropriately round and fleshy. Tao-chi's seal, Tsan-chih shih-shih-sun, A-ch'ang ("A tenth-generation descendant of Prince Tsan, A-ch'ang"), which appears on this leaf and also on leaf 12, proudly proclaims his Ming royal lineage. The use of such a seal and inscription in Tao-chi's earlier years, when the Manchu rule was still new and harsh, would have been inconceivable.

榮承三風味偏隹飽費蔡多
鹽漿蘭老夫今日聽羞此味嘗粟辣
蓬生番邵別此根芽
石濤濟枝下

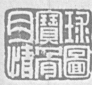

9. LAKESIDE GEESE

The composition, a classic "level distance" *(p'ing-yuan)* view, appears many times in Tao-chi's work. Here the wintry trees and rocks take on deep emotional significance with the addition of lines from Tu Fu:

> *Wild geese from the lake fly in pairs —*
> *When the veterans return from the old*
> *northern campaign.*

Geese are seasonal birds. In this somber scene, they are evidently returning from the northern country, which the southern Chinese remember historically as a land of bitter hardship and border warfare. The forbidding atmosphere supports Tu Fu's well-known antiwar sentiments. The figure on the bridge may again represent Tao-chi.

While the brushwork is exceptionally brusque and taut, the emotional intensity of the scene is achieved largely through the expresssive use of the ink, notably in the staining of the sky. In the *Hua-yü-lu,* chapter 5, Tao-chi writes:

> The splashing of the ink around the brush comes by instinct, while the manipulating of the ink by the brush depends on spiritual energy. Without cultivation, the ink-splashing will not be instinctive, and without experiencing life, the brush cannot possess spiritual energy.

The way in which Tao-chi plunges down his brush, spraying dots around rocks like bullets and raising dense clouds around the thorny twigs, bespeaks power and control that is at once innate and cultivated. From the single blades of grass in the foreground, through the vibrant, wintry branches, to the gliding birds in the sky, there seems to be one continuous vital "breath" *(ch'i)* permeating and uniting the different elements.

The pictorial presentation is reinforced by the squat, unpretentious "regular" script in the Chung Yu style, recalling that on leaf 7.

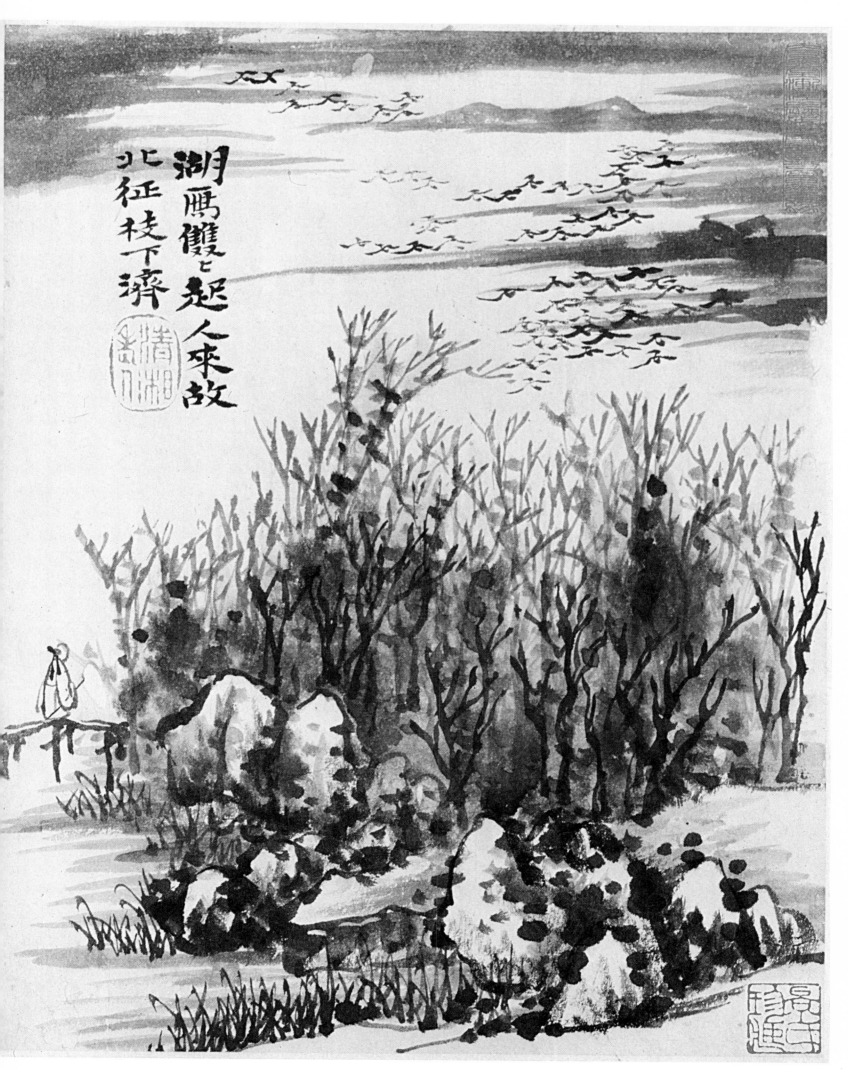

湖鴈雙々起
人來故
北征枝下濟

10. MOUNTAIN-BLOCKED CLOUDS

Tao-chi's inscription adapts two lines from Tu Fu and adds a comment of his own:

> *It is good not to have any houses here,*
> *Yet to have mountains blocking the clouds.*

> These words are unusual, and this painting is also raw! There is a feeling beyond feeling, and yet no hint of an ordinary painting.

Here we have a case of Tao-chi changing the wording of verses to enhance their pictorial interest. Tu Fu's original lines read:

> *It is good not to have any houses here,*
> *So nothing obstructs the cloud-covered mountain.*

While in real scenery the absence of any man-made structure indeed dramatizes the purity of a cloud-covered mountain view, in painting the idea of a cloudy mountain is so commonplace that the missing house alone can hardly make the painting exciting. By altering one word, Tao-chi deftly changes the sense of the second line and makes his pictorial subject the cloud, rather than the mountain. A poetic scene becomes an exciting one.

The unusual use of colors suggests a novel combination of the "blue-and-green" style with the "boneless" (see leaf 3). The absence of inked forms—hence "no hint of an ordinary painting"—makes his "raw" painting look like a colored apparition in the sky.

The writing, in a block, is executed in a restrained "running" script, close to that found on leaf 5.

II. PAVILION REFLECTIONS AT SUNSET

Again, lines of Tu Fu provide the inspiration:

> *The water is calm—the pavilion's reflection is straight;*
> *The mountain in dusk—the sun slants across the frontier.*

There is timelessness in this scene of a remote hamlet. The dense arrangement of the elements adds to the feeling of enclosure and security. One imagines the scent of the lotus flowers, the moist touches of scarlet filling the atmosphere with a heady perfume, relieved only by the light breeze that moves the willow branches. Both the poem and the painting should be savored slowly. The great Northern Sung landscape painter Kuo Hsi (about 1020–1090) wrote in his *Essay on Landscape Painting (Lin-ch'üan kao-chih):*

> It is said, "Poetry is invisible painting, and painting visible poetry." In my leisure hours, I often peruse Chin and T'ang as well as modern poetry, and find that the best of them give full expression to one's innermost thoughts and describe the scenery vividly before one's eyes. Yet unless I dwell in peace and sit in leisure, with windows cleaned, the desk dusted, incense burning, and ten thousand worries subdued, I am not able to appreciate the good lines and imagine the subtle feelings described in them. The same is true of the meaning of a painting. Why should it ever be easy to grasp?

The inscription, in a "regular" script similar to that found on leaves 7 and 9, is written in a comfortable and leisurely fashion. It mirrors the solid, self-contained feeling of the landscape.

水靜樓陰直山昏
寒日斜　石道人

12. ORCHID AND ROCK

The Chinese orchid is an extraordinarily fragrant plant. Its symbolism is mentioned in the earliest surviving Chinese literature. Orchid and rock, representing fragrance and strength, together symbolize excellent moral virtues. The *I-ching (Book of Changes)* says: "When speech comes from kindred hearts, it has the fragrance of the orchid." The ancient Chinese wore orchid leaves as tokens of friendship.

Tao-chi goes a step beyond the usual associations and makes the orchid and rock symbols of "ancestor and nation" *(tsu kuo)* or father-country. The clue seems to be an expression from a commentary of the third century B.C., the *Tso-chuan:* "The orchid has the national fragrance." With this leaf Tao-chi pays tribute to his ancient culture in all his capacities: as painter, calligrapher, poet, and now patriot. The calligraphy, in the style of Chung Yu, is immaculate. The poem, Tao-chi's own, is couched in the form of the ancient "Li-sao" ("On Encountering Sorrow"). The phrases are archaic, the tone openly sentimental:

> The stone god chips away,
> And moss-dots descend from heaven;
> When speech is pure and quiet,
> It feels doubly open and clear.
>
> How long have the orchids grown along the path and flourished?
> Spreading a fragrance, each blossom is breaking through its calyx.
>
> The rock represents the ancestor, and the orchid the nation —
> They each have a deportment that is easy and gentle.
> For quiet and slow conversation and for picking as a present —
> I will use only the orchid.
>
> I wait expectantly to express my private thoughts —
> Standing by my door I order myself a drink.

The inscription concludes with a full, formal signature: "Ch'ing-hsiang Shih-t'ao, Chi, painted under the Ta-ti-t'ang," followed by the seal, also to be seen on leaf 8, that records the painter's Ming imperial lineage: "A tenth-generation descendant of Prince Tsan, A-ch'ang."

石神鑿苦天荒言清幽倍軒豁伊何年之開徑而瀰敷以芳
馨兮紛含香而吐萼或名祖而名國兮嗣淡靜以綽約言
採折以贈貽兮非君子其誰托卿延竚以舒懷兮撫橝樞而
命酌

清湘石濤濟大滌堂下

NOTES

NOTES

1. An English translation of the entire text is in *The Chinese Theory of Art*, by Lin Yu-tang, London, 1967. The original text appears in *Hua-lun-ts'ung-k'an (Anthology of Painting Theories)*, Volume I, Peking, 1960.

2. Quoted in Cheng Cho-lu, *Shih-t'ao yen-chiu (Study of Shih-t'ao)*, Peking, 1961, page 31.

3. From an inscription on leaf 10 of an album of twelve paintings recorded in P'an Cheng-wei, *T'ing-fan-lou shu-hua-chi (Catalogue of Calligraphy and Painting in the T'ing-fan-lou Collection)*, preface dated 1843.

4. *Hua-yü-lu*, chapter 3.

5. *Hua-yü-lu*, chapter 3.

6. *Hua-yü-lu*, chapter 1.

7. *Hua-yü-lu*, chapter 3.

8. The date is based on two colophons by Tao-chi on paintings by Chu Ta (1626–about 1705): Narcissus, with inscription dated in the second lunar month of 1697, see *Ta-feng-t'ang ming-chi (Chinese Painting from the Ta-feng-t'ang Collection of Chang Dai-chien)*, Kyoto, 1955–56, Volume III, plate 9; and Painting of Tao-chi's Studio Ta-ti ts'ao-t'ang, with inscription on its mounting dated 1698, see Shen C. Y. Fu and Marilyn Fu, *Studies in Connoisseurship: Chinese Paintings from the Arthur M. Sackler Collection in New York and Princeton*, The Art Museum, Princeton University, 1973, catalogue number 23.

9. Richard Edwards et al., *The Painting of Tao-chi*, Ann Arbor, 1967, pages 63–70.

10. Fu, *Studies in Connoisseurship*, catalogue number 3.

11. Later examples of Tao-chi's "regular" script are looser, not so carefully executed in the individual strokes, as in the large *Album of Landscapes*, dated 1703, in the Museum of Fine Arts, Boston, published in Edwards, *The Painting of Tao-chi*.

12. Chang Keng, *Kuo-ch'ao hua-cheng-lu (Biographies of Painters of the Ch'ing Dynasty)*, preface dated 1739, part 3, folio 1.

In addition to the publications cited in the Introduction and the notes, these provide further information about Tao-chi:

Victoria Contag, *Zwei Meister chinesischer Landschaftsmalerei,* Baden-Baden, 1955.

Richard Edwards, "The Painting of Tao-chi: Postscript to an Exhibition," *Oriental Art*, Volume 14 (Winter 1968), pages 261–270.

Wen Fong, "A Letter from Shih-t'ao to Pa-ta-shan-jen and the Problem of Shih-t'ao's Chronology," *Archives of the Chinese Art Society of America*, Volume 13 (1959), pages 22–53.

————, "Reply to Professor Soper's Comments on Tao-chi's Letter to Chu Ta," *Artibus Asiae*, Volume 29 (1967), pages 351–357.

Osvald Sirén, "Shih-t'ao, Painter, Poet, and Theoretician," *The Bulletin of the Museum of Far Eastern Antiquities,* Volume 21 (1949), pages 31–62.

In Chinese

Cheng Wei, "Lun Shih-t'ao sheng-huo, hsing-ching, ssu-hsiang ti-pien chi i-shu ch'eng-chiu" ("On Shih-t'ao's life, intellectual development, and artistic accomplishments"), *Wen-wu*, Volume 12, Number 6 (1962), pages 43–50.

Fu Pao-shih, *Shih-t'ao shang-jen nien-p'u (Shih-t'ao's Chronology)*, Shanghai, 1948.

THE WILDERNESS COLORS OF TAO·CHI

was designed by Peter Oldenburg. The type was set by Finn Typographic Service. Village Craftsmen printed the text and facsimile color plates on specially made Natural Rotunda paper. The book was bound by A. Horowitz and Son.